The Graphic Art of Paul Fournier

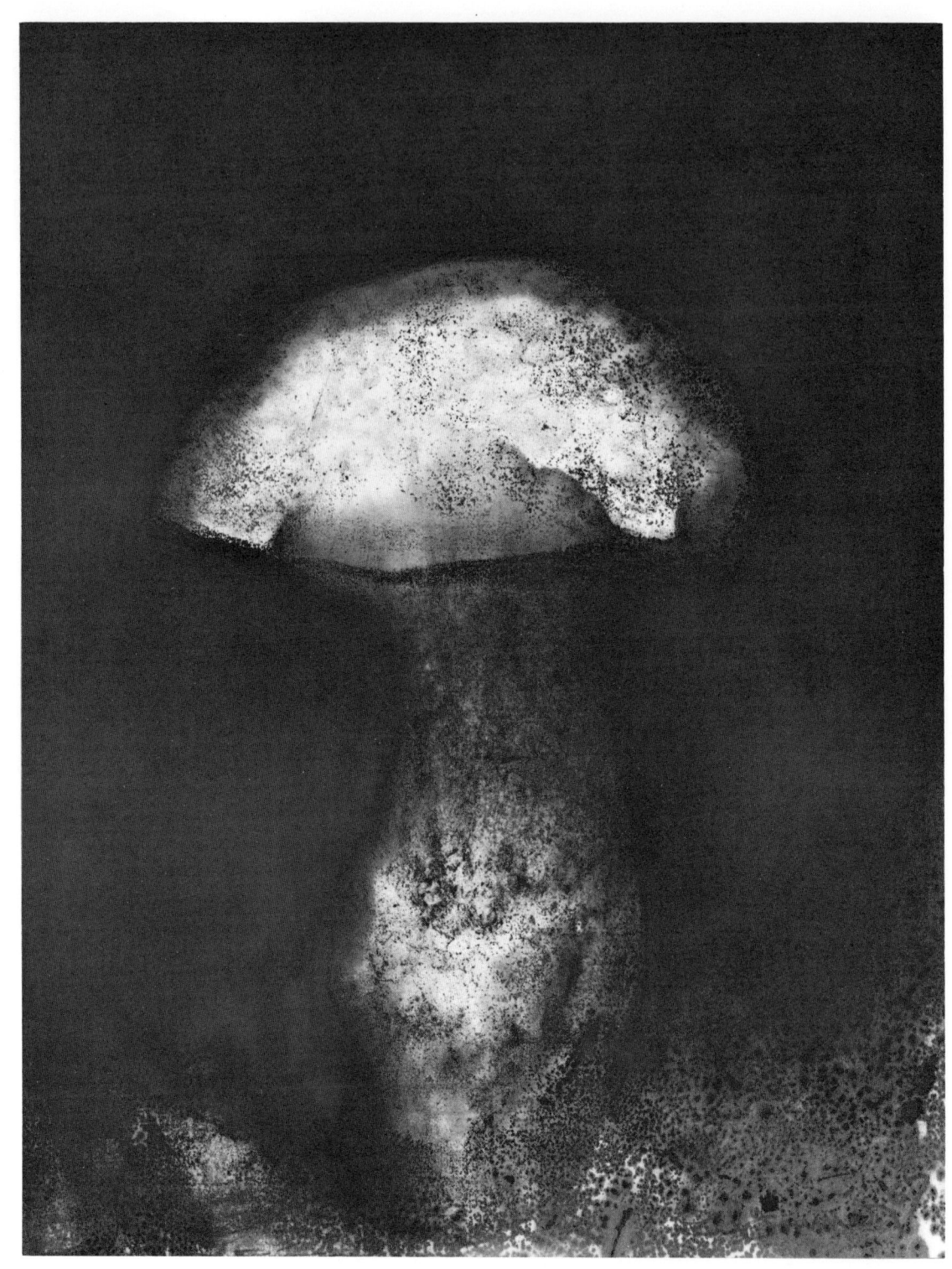

'Agaric Presence' 1972. Monoprint, Dry Brush & Wash. 8½″ × 11″.

THE GRAPHIC ART
OF PAUL FOURNIER

edited by Greg Peters

The Porcupine's Quill, Incorporated

Copyright © Greg Peters, 1981.

Published by The Porcupine's Quill, Inc., 68 Main Street, Erin, Ontario N0B 1T0. Financial assistance towards publication of this book was provided by the Canada Council and the Ontario Arts Council.

Except where noted, the works used for reproduction have been taken from the collection of the Westdale Gallery, Hamilton, Ontario, or the collection of the artist.

Distributed by Firefly Books, 3520 Pharmacy Avenue, Unit 1C, Scarborough, Ontario M1W 2T8.

Typeset in Bodoni Book by Trigraph (Toronto), printed and bound by The Porcupine's Quill, Inc. in October of 1981. The stock was supplied by the Monadnock Paper Mill (New Hampshire).

Cover is after 'Hanging Crow No. 1' 1968. Etching, edition of 50. $14^{3}/_{4}'' \times 23^{1}/_{2}''$.

ISBN 0-88984-045-8

FOREWORD

This book would not have been realized without the cooperation of a number of individuals. I wish to thank Professor George Wallace for contributing an article for this work, and Mr. and Mrs. Joseph Lees, David Taylor, curator of the McMaster University Art Gallery, and Mr. Julius Lebow of the Westdale Art Gallery for permitting me to peruse their collections.

In particular, this work owes a great deal to Mr. Julius Lebow. Not only was the initial idea of making the book his, but he always made himself available for my numerous questions throughout the months.

Lastly, I wish to express my gratitude to Paul Fournier. In preparing this book, I have drawn upon notes taken during conversations with the artist himself. I am truly indebted to him for his patience and kindness.

G.P.

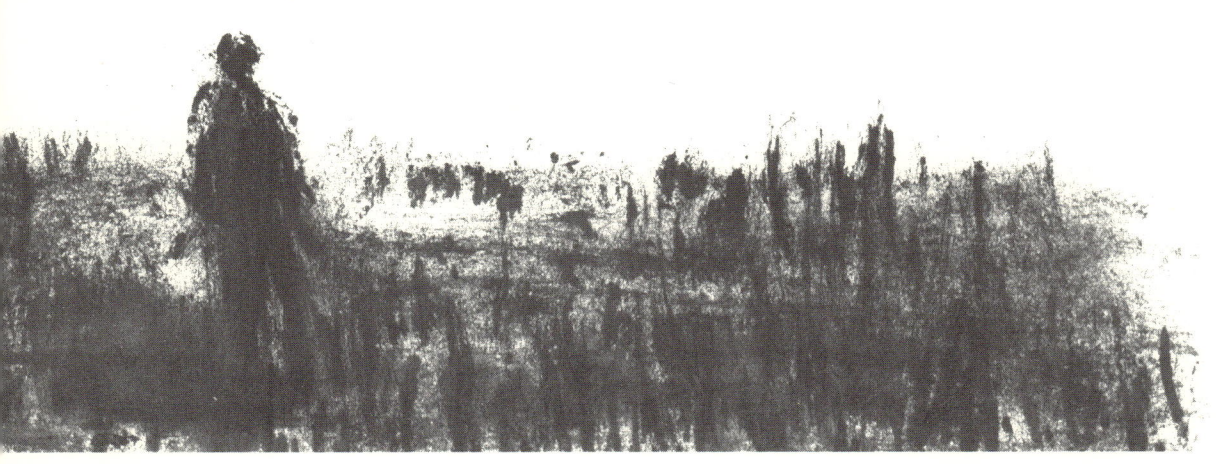

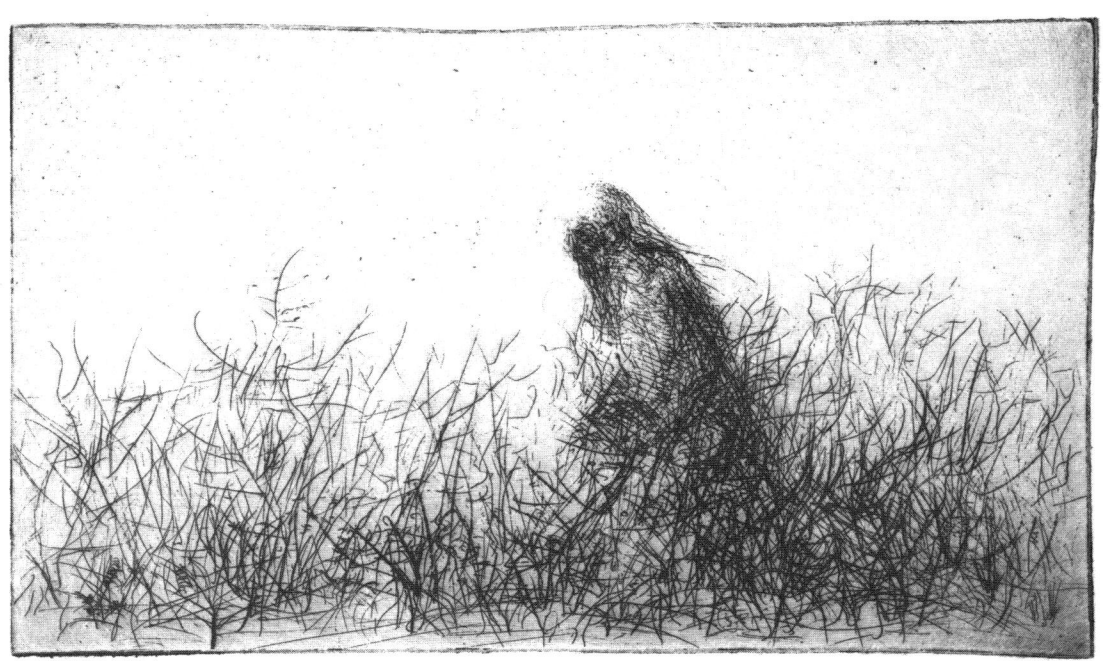

'Prophet Emerging' 1968. Etching. Artist's Proof, First State. 5½" × 3½".

THE GRAPHIC ART OF PAUL FOURNIER

Graphic art contains qualities indigenous to itself. Because of the general absence of colour, the drawn or etched line must be all expressive. It is unhidden, immediate. And since a drawing need not be regarded as a 'finished product', an impression of spontaneity and intimacy is often achieved with greater ease than in more formal visual processes.

To a large degree, Paul Fournier's reputation as an artist rests on his abstract paintings. From the 'Apocalypse' paintings of 1974 to the 'Florida Mirrors' of 1977, Fournier has been acclaimed for his utilization of texture and colour. It is an exciting experience to let one's eyes travel the long walls of his studio where, from one huge canvas to the next, colours brightly swirl and dance. Forms appear, are transformed and reappear. Everything is in motion. Viewed collectively, Fournier's more recent paintings are like a joyful symphony he has offered to mankind.

The graphic work of Paul Fournier reveals another facet of this versatile artist's *oeuvre*. Examine, for example, the etchings of field animals, some less than two inches wide. Instead of the sweeping interplay of abstract elements, we view intimate portrayals of precise draughtsmanship. In many of his etchings and drawings, Fournier depicts nature in microcosm. Here, a figurative approach best suits his needs. Thus Fournier permits the particular medium to shape his method.

Surprisingly, Fournier experienced greater difficulties gaining credibility with his representational works than with his later abstract paintings:

> I had more problems as a representational artist because people then thought they had a right to dictate to you, to judge you, to tell you what you were doing or weren't doing right; whether the trees were blowing in the right way, or that the grass was never really that tall, or that a particular landscape was 'too much like Norway', or, simply, 'that's where George hunts ducks'.

THE ETCHINGS

> 'I have always had an intense empathy with nature and it still remains my prime source for artistic invention.'

The majority of etchings, drypoints and serigraphs date from 1966-68, when George Wallace made the printmaking facilities at McMaster University, Hamilton, available to Fournier. The prints, many depicting bats, moles, rats and birds, tend to be in series form and range in size from miniatures to the large 'Hanging Crow', measuring fourteen by twenty-three and a half inches.

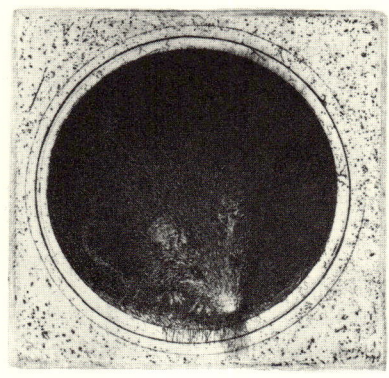

'Rat Emerging' 1968.
Etching, Artist's Proof of First State of Two. 2″ × 2″.

Fournier says that the challenge, with the miniature etchings, was 'to get something small and make it alive'. There is a strong sense of mystery in these tiny portrayals of field animals, a sense for the spectator of being on the threshold of a fragile, alien world. In this light, Fournier is quick to acknowledge the important role the sentiments of childhood play in his art: 'When I create, I'm like a child turning a stone over'. He speaks of 'the joy of discovery', of the child uncovering foreign worlds: 'Anything that crawled, intrigued me'. And thus in these etchings the most minute details are accurately rendered by a multitutde of cross hatchings, as if with the eager eyes of a boy, he is absorbing everything there is to observe in these small, strange creatures.

Some of Fournier's paintings from these years convey a similar sense (see for instance, the 'Distant Marsh' paintings of 1966). But whether it is the technique employed or the tiny size of the prints themselves, it is the etchings which seem to render the more intense impression of mystery. In 'Bat No. 1', all but the nose and ears of the subject are concealed by a soft fine blanket of fur. It is wrapped within itself, hiding its secrets. In 'Bat No. 2', 'Bat No. 3' and 'Bat No. 4' all is solemn and still; there isn't a whisper of movement. This atmosphere of silence is again noticeable in the 'Mole' etchings and in 'Rat Emerging', where the dark world of the rat is contrasted with the brilliant light at the end of the pipe. In fact, through Fournier's delicate execution of form within shades of darkness, one can sense the fear of the animal—its almost hushed quivering—as it cautiously enters into the light.

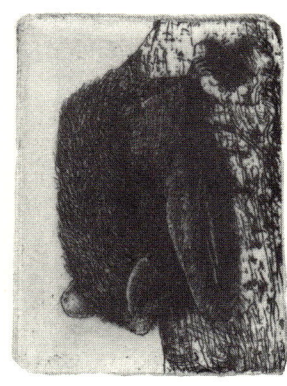

'Bat No. 1' 1968. Etching, edition of 20. 1½" × 2".

Similarly in a larger etching entitled 'Mouse Emerged', the animal has fully left its world of darkness behind. Very vulnerable in the light, it stares directly at the artist. It's sense of danger is acute. A front claw is placed lightly on the ground, indicating that at the slightest warning it will spring for protection. This is a confrontation between two strangers; the artist and the animal. And in 'Mole No. 2', the animal is completely exposed. Claws lying uselessly at its sides, it appears incapabale of any movement or effort to protect itself.

In the more sizable etchings of birds, the plates have been bitten with acid in several stages, creating a more pronounced texture in the lines comprising the feathers. In one study, the bird lies lifelessly on its back. Background has been entirely eliminated in order to focus all attention on its form. Death leaves its mark in the eyes and in the open mouth. The gnarled claws, in particular, appear to illustrate the last, hopeless struggle to maintain life.

The largest prints analyse similar themes. The gigantic 'Hanging Crow No. 1' and 'Hanging Crow No. 2' are masterful examinations of form and death. Wings awkwardly dangling, feathers matted, the crow's contorted corpse hangs from a hook. Its crossed legs have been bent in order to provide a catch. There is an overwhelming sense of sadness in this image. Even in the etched artist's proof of the twisted claws one feels a waste of life, a deformation of nature.*

Landscape plays a large role in the serigraph entitled the 'Flute Player' and the 'Reed Figure' etching. Here, half-hidden, half-human forms are depicted in a mysterious undergrowth. A thick patch of marsh is represented in another landscape. Fournier sees and feels a force working in all of nature. The marsh, like the field animals, is home to the same quiet secrets.

In his graphic art, Fournier has always been attracted to faces. 'Heads', he says, 'are all expressive'. In 1969, he completed a set of small drypoint studies on this subject. (Of all the printmaking methods, Fournier claims the drypoint appeals to him most strongly because of its 'directness'.) The faces are often aged and some exhibit mystical characteristics akin to those of scribes or prophets.

Fournier arranges a composite image by contrasting five or six heads on

*And yet there is a beauty in natural forms that even death fails to destroy. In 'Hanging Crow No. 1', one is intrigued by the fossilized pattern of the unfolded wings.

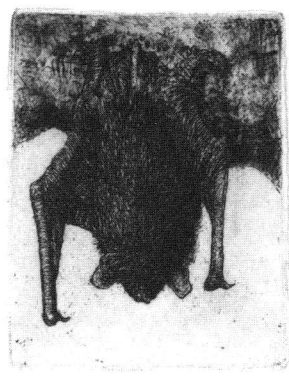

'Bat No. 2' 1968. Etching, edition of 50. 1½" × 2".

some plates, and attempts to capture an expression with a few bold lines. The finest of these faces exhibit a moving veneration for humanity.

Paul Fournier's printmaking techniques from this period are varied. There are drypoints, serigraphs and hard and soft ground etchings, ranging in size from the miniscule to the monumental. Some plates were also reworked after each pull. Thus in etchings such as 'Bat No. 4' and 'Between the Tides' there are over one dozen states, with every print comprising a separate edition, a unique work of art. In both prints, the central image is radically altered by changes in the background. In 'Bat No. 4', the wall the animal clings to is worked and reworked. In 'Between the Tides', the ocean floor undergoes an amazing number of transitions. When four or five of these states are grouped together, the artist's intent becomes clear. As the water advances and withdraws, it casts completely different patterns on the ocean floor, in turn affecting the way we perceive the dead crab. Even in death, its appearance is subject to the fluctuations of the constant tides.

These prints are obviously not just exercises in craftsmanship, for no matter what the subject or method, all convey a deep spiritual sense. Fournier's feelings for nature place him in the romantic as opposed to the classical tradition. Whether it be a huge hanging crow, a field figure, the portrayal of a face or a fragile field animal, there is invariably something hushed and tender in the image.

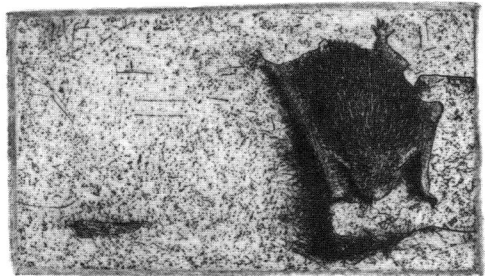

'Bat No. 3' 1968. Etching, edition of 20. 2½" × 1½".

EARLY DRAWINGS

'Everything has a presence, a language.'

Paul Fournier's art reaches beyond the surface appearance of things. Every landscape, face and animal is interpreted and connected to the 'human drama'. This is apparent even in the early drawings, dating from 1960-61, in which an arid desert landscape becomes a backdrop for an army enacting a bizarre form of ballet.

Entitled 'The Prophetic Series', the artist observes that the set was influenced by Biblical prophecy: 'I saw humanity, clumped in a mass, going through the seasons'. From one drawing to the next, faceless figures march, chase and skirmish over a lifeless, seemingly endless terrain. No prizes are to be won here, no glorious conquests. A pair locked in combat becomes a furious circle, an aimless tumbleweed wandering through a dead world.

Here movement plays a very large role. Fournier says that when he was at work on the series, he 'became interested in dance, in the figures and gestures of people, to the point that I closely began watching them cross the street'. The individual is lost in group movement as each figure comes to represent a study in pure form. Even in 'Desert Figure', in which a single character is portrayed, the face is nearly featureless and the body seems to melt away into the desert haze.

Then there are the hordes of marchers. Standing at a distance, against the flat wash background, they appear like symbols or letters from a long forgotten language. Every figure is 'read' against the line of the horizon. But with each advancing step, their appearance alters—there is now motion and mass. They begin to close in, collectively dominating the landscape. In one drawing, they are almost upon us. Banners raised, they present a threatening image of merging blackness.

Fournier's art is at its starkest in a collection of large scale drawings dating from 1961 to 1966. Many are representations of beggars and hanged figures and a large set depicts the twisted bodies of soldiers randomly heaped together. Although these works are clearly related to the marchers from 'The Prophetic Series', the artist's temperament has radically changed. Abstract form and movement have vanished; the horrors of warfare and of man's cruelty now come to the fore. In one drawing, called simply 'Figure', thick aggravated lines on the lithographic plate vividly sketch an outstretched corpse. In the end, one is left with a sickening sensation of waste and decay.

The figure of Judas aptly stands as a symbol for these dark drawings, of what Fournier terms 'the rottenness within the human soul'. One of the 'Fallen Judas' drawings is reproduced in the text. He lies stomach down. A branch, indicating the hanging tree, is in front of him. His right forearm is still slightly raised. (The artist says that the drawing is based on 'a photograph of a war victim that had turned into a petrified corpse'.) This frozen pose epitomizes Judas's desperate suicide—the horror of sinning to the degree at which it is no longer possible to forgive oneself.

THE GIANT'S CAUSEWAY DRAWINGS

'Things seem to move, even when they are standing still.'

In 1968, Paul Fournier visited Great Britain. Exposure to foreign lands has always had a profound effect on his art. New sights and experiences are absorbed within him 'like a sponge', often producing bold departures in his work. See for instance, the 'Florida Mirrors' and 'Parrot Jungle' paintings.

In Britain, Fournier was immediately drawn by the unfamiliar light, particularly when viewed against solid masses of rock. This concern is in evidence in a group of paintings of the English coast known as 'The Devon Set'. Similarly, the graphic work examines the rock structure of the Giant's Causeway in Northern Ireland. In these pen and ink studies, dark shadow is carefully contrasted with various shades of light, and we feel the artist's excitement as the light appears to slowly move and reshape these smooth, monumental forms. Fournier says:

> I like dramatic things with sharp contrasts. They seem to represent the mystery of life and the forces that lie behind things — that energy there. I am drawn to mystery, but through my art, I like to explore and reveal it.

With a labyrinth of lines and cross hatchings, Paul Fournier scrutinizes the Giant's Causeway from a multitude of angles and lightings. In every drawing, he is seeking out the mystery. The rocks always remain silent and yet there is a life within them. It is as if these huge pillared shapes are a natural shrine, the ruins of a cathedral spanning the ages. Through his art, Fournier gives meaning to these inadvertant rock clusters.

One etching was also completed on this subject. It is a remarkable work in that Fournier has conveyed a sense of great mass in a print which barely measures two inches across. Moreover, the effect of light and shade has been delicately rendered in a medium in which colour is absent. Against the smooth rock surfaces, the remnants of dying light take on a spiritual luminosity.

'Giant's Causeway' 1968. Etching, edition of 50. 2″ × 1½″.

ANIMAL PORTRAITS

'I feel I almost become the thing I'm looking at.'

Many of Paul Fournier's drawings of animals are represented in series form. Throughout most of his career, Fournier has worked within this framework. One of the reasons, he says, is that:

> A good work may criticise what preceeded it, and quite often a breakthrough comes as a surprise. That's why I don't start off a creative work as a finished concept.

Fournier never, therefore, permits the picture to be completely governed by preconceived notions. His art is formed and modelled by an ongoing process. Upon completion, the work becomes 'an entity in itself, speaking its own language'.

A striking characteristic of Fournier's animal drawings is the intimacy in which they are portrayed. Some of the drawings in these sets — the parrot heads of 1965, the hermit crabs of 1967 and 1969, the toros series of 1968, the monkeys of 1973 and the camels of 1974, for example — are closely akin to portraits in their methods of

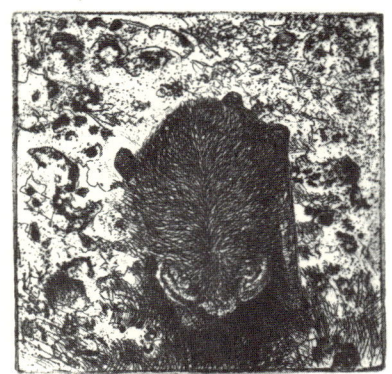 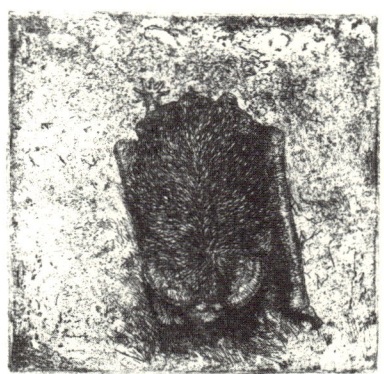

'Bat No. 4' 1968. Etchings, Four Artist's Proofs. 2" × 2".

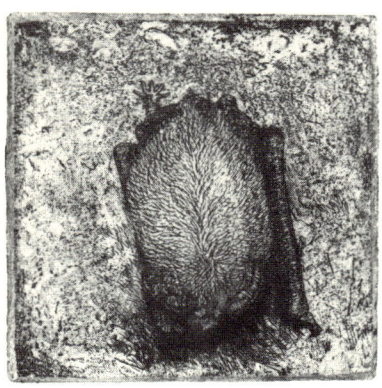 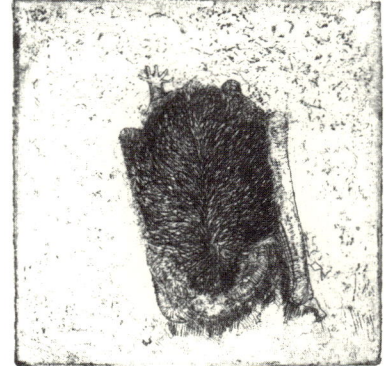

composition. Often the animal's image is cut at chest or neck level, the background is uncluttered with diverting embellishments, and the animal gazes directly at the artist, imitating the dramatic relationship between portraitist and sitter. The pose is still and silent, and the closed space between the eyes of the subject and those of the artist takes on an intense energy. It is as if we are forced to view the animal on equal terms: we regard it while it regards us.

Some of the drawings are reminiscent of the smaller animal etchings in their accurate rendering of detail (see 'Hummingbirds'). Others however, employ a greater economy of line or an ink wash, in which several broad strokes are used to convey a sense of the animal rather than a strict depiction of its physical proportions. This is particularly true of the later drawings, in which Fournier moves entirely away from naturalistic art in order to concentrate on the spirit of the animal. In 'Camel with a Foamy Mouth', the snout and eye are all that is necessary to convey the animal's comical presence. With a toros drawing, Fournier requires but a few thick brush marks to capture the bull's incredible strength.

Three drawings of monkeys, dating from 1973 to 1981, are reproduced in this text: one is a wash, another a pencil study and the third a pen and ink. They are indicative of Fournier's technique mastered in his later drawings. Much more expressionistic, these works suggest rather than describe. To a greater extent, the picture is 'speaking its own language'.

Although Paul Fournier has drawn a number of faces, his most impressive portrayals are generally animals. Perhaps this is because people often appear at a distance from the artist's primary creative source, nature. And thus when Fournier depicts a human form in the strongest light, such as the 'Field Figure' drawing, the 'Reed Figure' etching or the 'Flute Player' serigraph, the subjects have hauntingly blended with their environment to become an element of nature itself. In each of these works, it becomes almost impossible to discern where the human form ends and nature begins.

THE MUSHROOM SERIES

'In this series of work, I wanted to show the mushroom in a new light, exposing the hidden wealth of fascinating forms, shapes, patterns and textures of a large variety of fungi.'

Paul Fournier's most extensive graphic set is 'The Mushroom Series'. Completed during the summer of 1972, the artist's sources were actual specimens. Fournier's employment of texture is here best seen. Thus most of the works (over sixty in all) are monotypes, where the image was painted in ink wash or brush on a lithographic plate. For the impression, the paper was lightly pressed on the plate, lending a velvety blackness to the finished prints. In others, the textural qualities are blotchy and irregular, perhaps intimating the perpetual shiftings in the appearance of these forms of life.

'The Mushroom Series' covers a tremendous range in technique and temperament; 'some are comical, some are frightening'. In a number of works, the dark background takes on the likeness of a mezzotint. In others, in which a loose wash or brush drawing is added, it reveals qualities found in lithography. In either case, Fournier's utilization of the monoprinting technique closely aligns these prints to his paintings.

Initially, the most striking quality of these monoprints and drawings is their inflated size. The majority are printed on paper measuring twenty-four by thirty-six inches. And in this light, it is impossible not to be reminded once more of the importance of the creative imagination of childhood in Fournier's art. From the tiny etched pillars of 'The Giant's Causeway' to these immense mushroom monoprints, it is as if we have entered an 'Alice in Wonderland' setting.

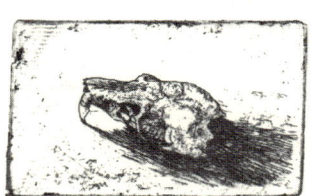

'Mouse Skull' 1968. Etching, Artist's Proof. 1½" × 1".

Artistic distortion of size illuminates new avenues of expression. Fournier says that he chose to deal with the mushrooms in an expanded size in order to, 'express both the presence and personality of each mushroom more effectively'. Surely, on this scale, 'personality' looms as the dominant force. The mushrooms seem almost human, having the ability to directly affect our emotions to such a degree that, at their first showing, some people were distinctly intimidated by the set. Fournier claims:

> One couple had to leave the show. They were taking a seminar in psychology and they said that there was just too much phallic imagery to cope with. Others saw an atomic explosion in the mushroom form.

Whether working on an abstract canvas or on a more representational level, such as the mushroom monotypes, Fournier labels himself an 'expressionist', a seeker of the subjective as opposed to objective truths. 'Although I am faithful to the botanical form and characteristics of each mushroom species, my drawings are not illustrative. My foremost interest has been with the aesthetic aspects and the expressive possibilities of the subject matter.'

As an expressionist, Fournier's 'prime source for artistic invention' is nature. And regardless of the image portrayed, there is a profound, silent sense of humanity in his art. It is this 'expression' which has guided him through an amazing number of methods and stylistic explorations in both prints and paintings in his still young career. (At present, the gulf between Fournier's paintings and graphic work appears to have diminished. To some extent, Paul Fournier now 'draws in paint'. His most recent paintings, in fact, contain calligraphic elements reminiscent of some of 'The Prophetic Series' drawings.)

From his paintings to his prints, the work of Paul Fournier is charged with a spiritual presence. It is impossible to confine this joy and sense of awe at the wonders of creation to any one method or style. The landscapes and animal studies reproduced in this book are all equally touched by his wonder and reverence; even a rat, emerging from the darkness into the light.

A NOTE ON THE ETCHINGS

I first met Paul Fournier in either 1959 or '60 soon after I came to McMaster University. I was introduced to him by Brydon Smith, now curator of Contemporary Art at the National Gallery in Ottawa, then a student of biology, who had recently become interested in art and had met a number of young Hamilton artists, including Paul. Paul was making very moody and romantic landscapes, many of them of the marsh areas on the edge of Cootes Paradise. These paintings, which I thought were the most interesting paintings being made in Hamilton at that time, were rich in colour and tonal contrast and very painterly in texture, with areas of quite heavy impasto.

In contrast to these very tonal paintings were some pen and ink drawings which Julius Lebow showed me in late 1965 or early '66, which were small in scale and minutely detailed in texture. The subject matter of these drawings was small animals and birds drawn from specimens in the collection of the Royal Ontario Museum. Paul was subsequently to tell me that in High School he had been interested in natural history and had, before he turned to painting, considered going to University to study zoology. When I saw these drawings I suggested to Julius that their precise and delicate linear texture would make them very suitable subject matter for etchings and that Paul, who had by then moved to Toronto, should come down to McMaster and learn the technique.

The idea of learning to etch appealed to Paul and early in 1967 he started to come down to McMaster on Saturdays. His usual practice was to arrive by bus in the early morning and work through the afternoon, sometimes returning to Toronto in the evening, but sometimes staying overnight and working again on Sundays. The frequency of his visits depended on how well his painting was going and what other commitments he had in Toronto. This situation continued through 1968 and into 1969, and during this time he produced about twenty plates. My recollection is that the first plate was a complete disaster and the first successful plate was a copper about $5\frac{1}{4}'' \times 6\frac{7}{8}''$ of a mole.* Paul frequently polished and grounded plates at McMaster, drew on them in Toronto and brought them back the next week to etch and prove them. This carrying of plates back and forth meant that some of the grounds got scratched which led to foul biting which had in turn to be scraped and burnished down. Some of this accidental texture can be seen in the background of this early mole print. He next made two plates $4\frac{7}{8}'' \times 6\frac{5}{8}''$ called 'Dead Bird' and 'Bird Study' and a larger plate, 'Hummingbird', which were drawn from skins of birds in the collection of the R.O.M. These plates show Paul exploring the different qualities of line that are possible to achieve in hard ground. I think that his most successful plates are either dry points or hard ground etchings, though he also made soft ground plates, aquatints and sugar lift aquatints. The largest of the plates are a zinc $23\frac{1}{2}'' \times 14\frac{3}{4}''$ and a plate about half that size both dealing with the 'Dead Crow'. The subject of

*Mole No. 1 — ed.

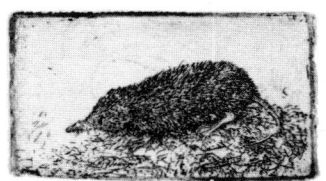

'Shrew' 1968. Etching, Artist's Proof. 1½″ × 1″.

these prints was a battered mummified crow which Paul kept in his studio on Markham Street. This mummy was the sole survivor of six, shot by Ron Baird one fall. Ron had twisted the legs of the dead crows together and hung them on a wire fence. This surviving corpse, dry and wind swept, had been found the next spring by Ron and Paul. Both of these prints illustrate Paul's technique of etching at its most complete. In both, the battered, attenuated bird, its tangled legs hooked over a wire, forms a black heraldic image against the paper. The texture of the ruffled feathers and dried skin are wonderfully realized in varied dots and lines but it is shape and particularly texture that is realized not form or a pattern of light and shade. Indeed, in neither of these prints can you discover from what direction the light is falling, nor is any shadow cast.

'Mole No. 4' 1968. Drypoint, Artist's Proof. 3¼″ × 2½″.

In 1968 the Pratt Institute in New York, remembering that prints had not always been thought of as big, brightly coloured and decorative but that they could also be as minutely small as the engravings of the Behan brothers, had the imaginative idea of holding an exhibition of small prints. For this exhibition Paul made a number of prints. These tiny plates, some are 1½″ × 1⅞″, are I think the most imaginative and witty of his prints. They include the visual joke of representing on such a tiny plate the 'Giant's Causeway'; the beautifully detailed 'Hanging Bat'; the extraordinarily spacious 'Between the Tides', which shows a small dead crab on a beach and perhaps the most appealing of all, the circular plate showing the end of a pipe from which a small rat emerges.

When, in 1969, Paul ceased his weekend visits to Hamilton, he presented to the McMaster University Art Gallery a set of the etchings he had made at the University, together with three of the cancelled plates.

I think that the achievement of these prints is twofold. They are technically

good examples of dry point and of line drawing through hard ground. These media are used in a great variety of ways and with accomplished and expressive skill which in itself is delightful. These etchings, however, are more than technically accomplished, their very sensitive and poetic evocation of small animals and birds has a haunting quality. The small delicate creatures he represents, so often seem to be in danger, if not actually dead. Many Canadian artists have seen nature in large and heroic terms. By contrast Paul Fournier in these prints presents a microcosm whose small scale and appealing vulnerability makes it extraordinarily poignant.

GEORGE WALLACE

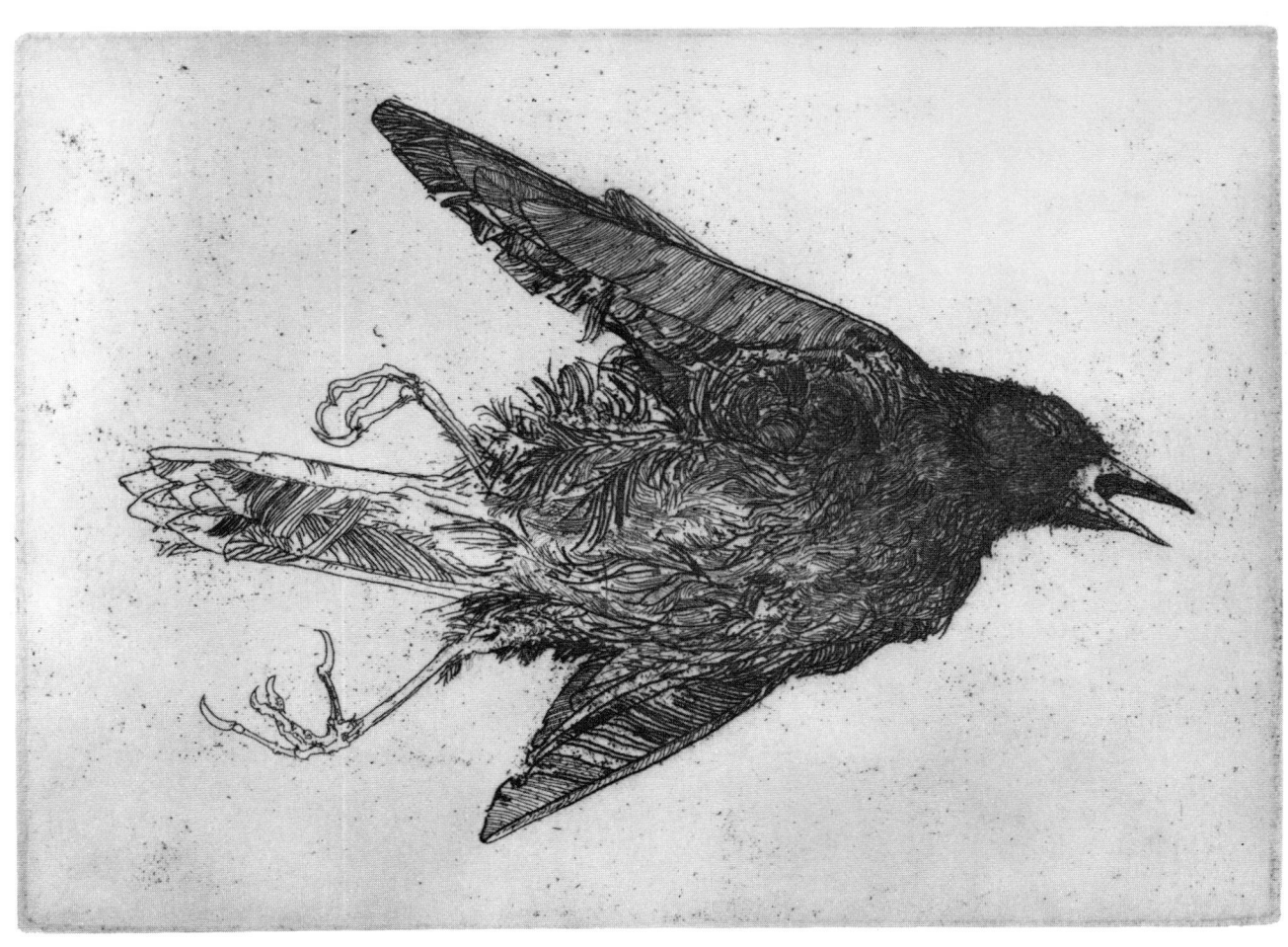

'Dead Bird' 1968. Etching, edition of 35. $6\frac{1}{2}'' \times 5''$.

SOME THOUGHTS

'I cannot put my faith in man's pride to redeem the world
from a crisis that is the product of that very same pride.'

'As lemmings toward a funereal sea, so is man's heart fixed
toward his apocalyptic destiny.'

'God's creation I hold close to my heart — and as the Navajo would say:
 Among them I walk,
 I speak to them;
 They hold out their hands to me.'

 — from SONG OF THE LONG POT

'In death, feathers have a different beauty,
The skeleton its own wonders.'

'My hope is in Love that once suffered, once was buried,
now is everywhere.'

 PAUL FOURNIER

'Desert Figures' 1962. Ink Wash Drawing. 16½" × 6".

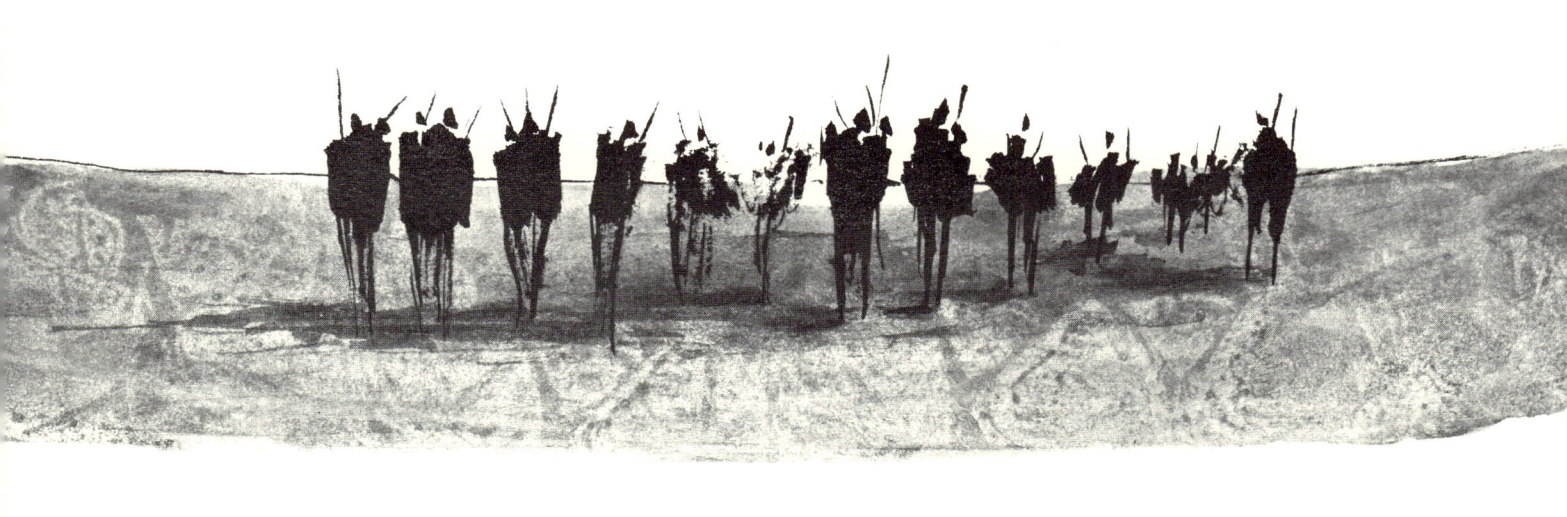

'Night Figures' 1962. Ink Wash. 14$\frac{1}{4}''$ × 10$\frac{3}{8}''$.

'Marching Soldiers' 1960. Drawing with Ink Wash. $6^{1}/_{2}'' \times 4^{1}/_{4}''$.

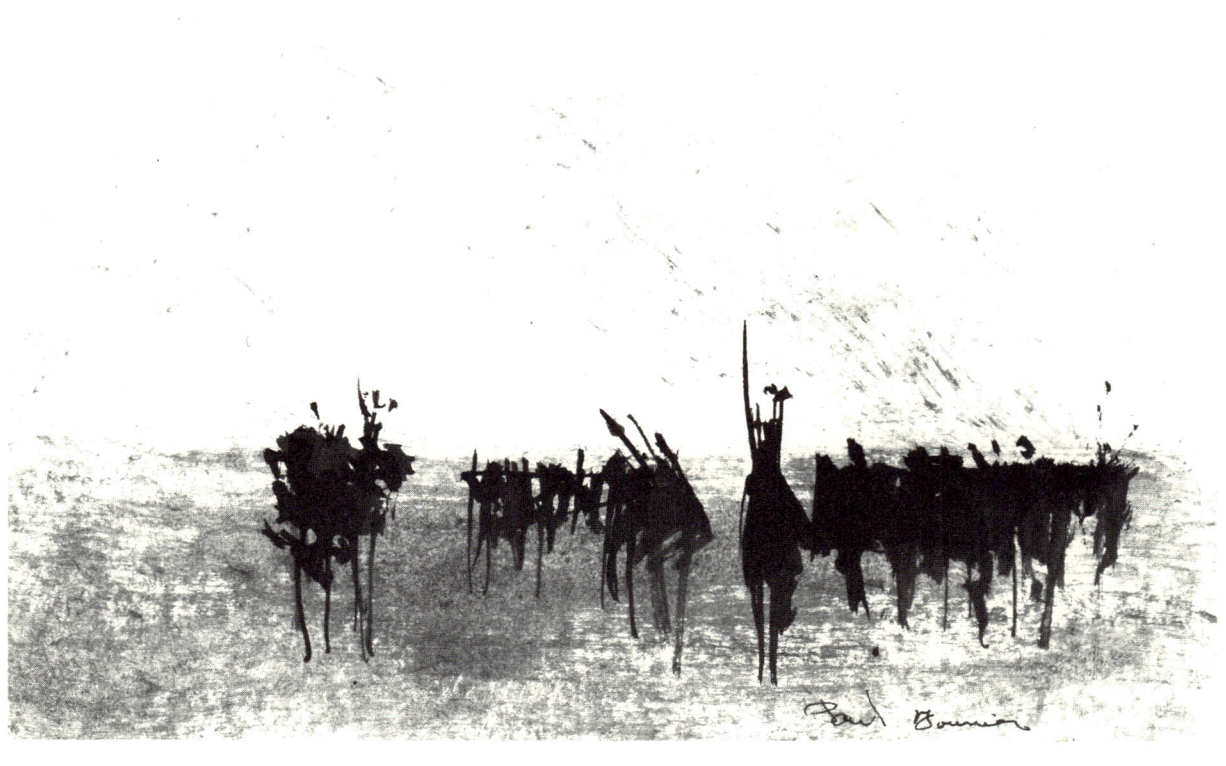

'Combat' 1960. Drawing with Ink Wash. 11″ × 6¼″.

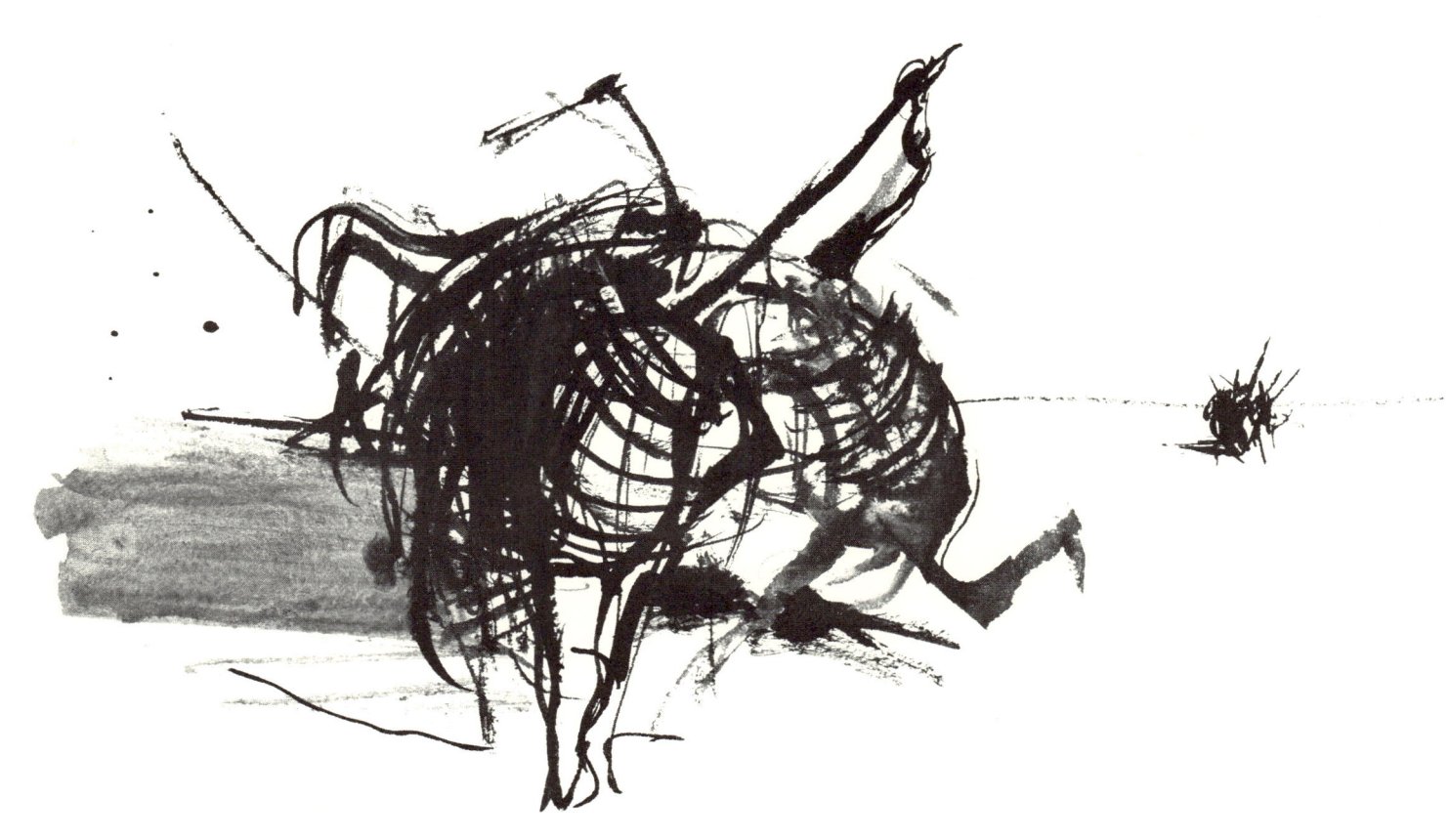

'Desert Figure' 1962. Ink Wash Drawing. $10^{13}/_{16}'' \times 9^{3}/_{4}''$.

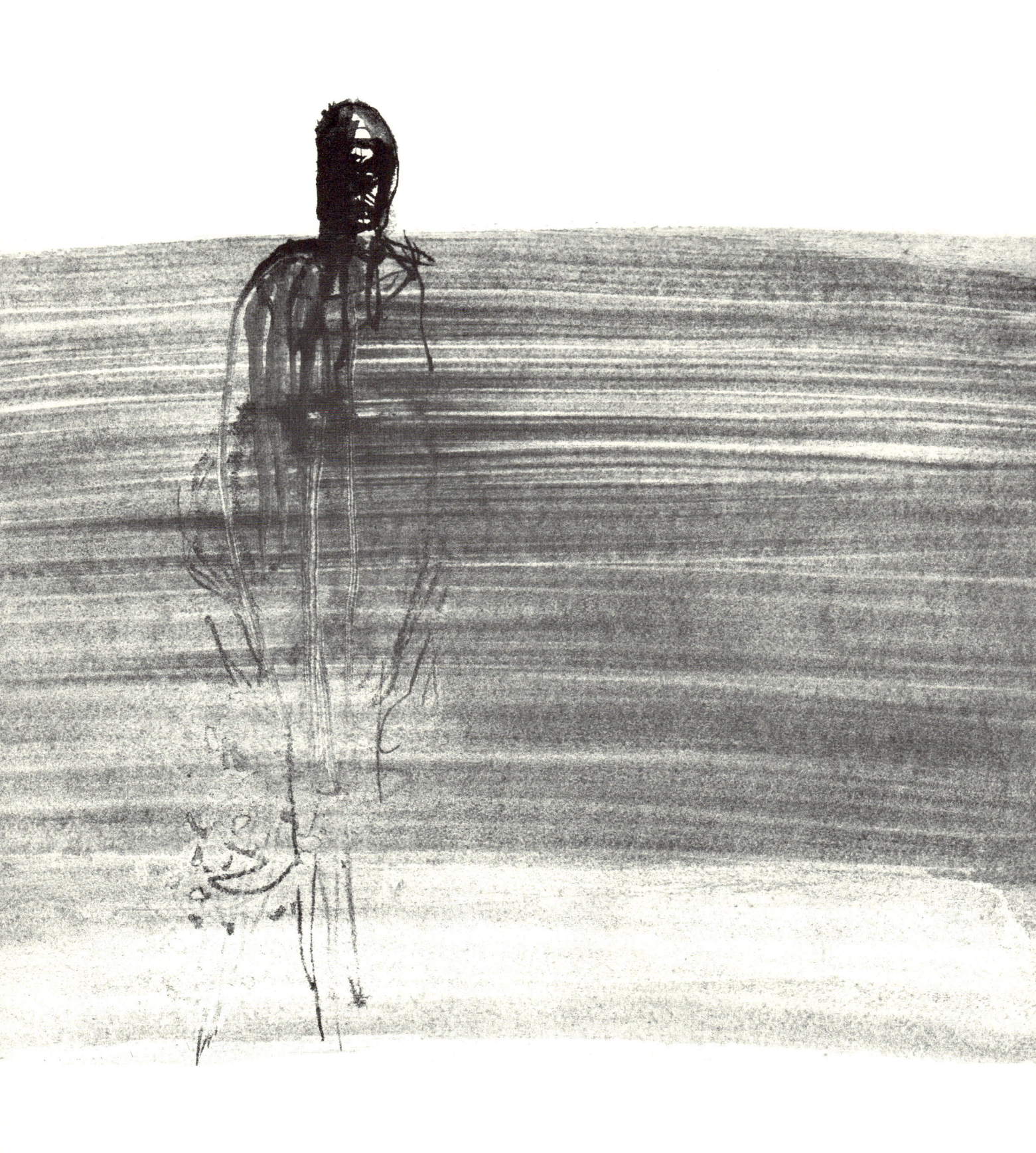

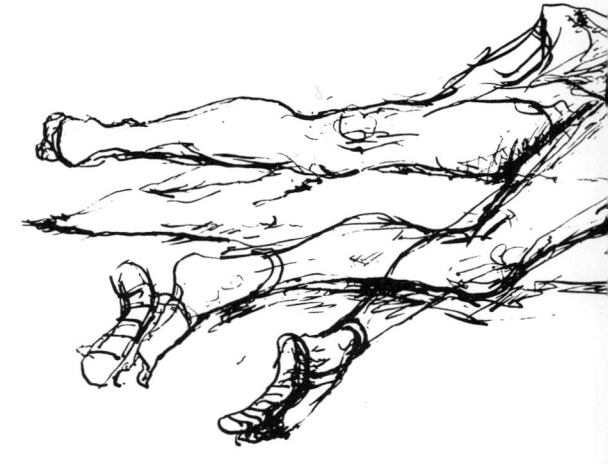

'Fallen Judas' 1966. Drawing on Lithographic Plate. $3^{3}/_{4}'' \times 11^{3}/_{4}''$.
Collection, McMaster University.

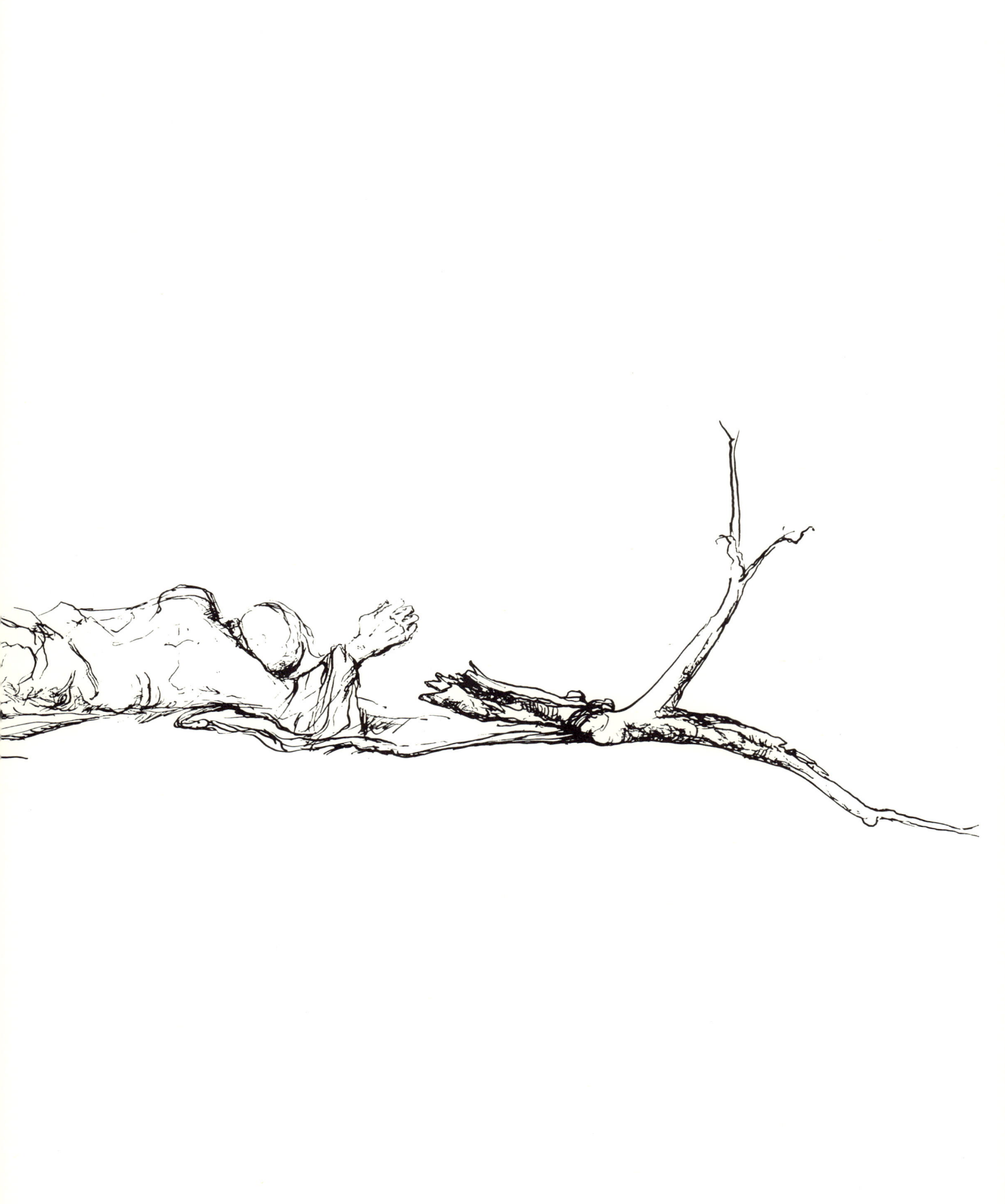

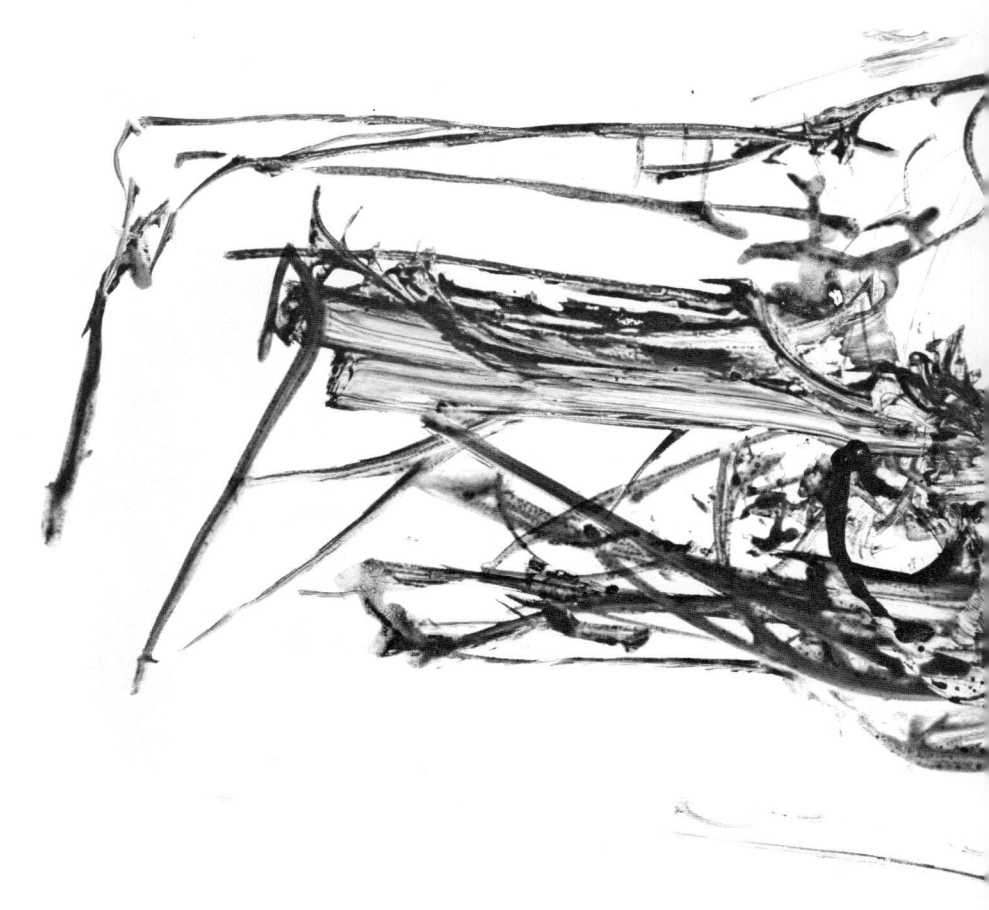

'Figure' 1966. Drawing on Lithographic Plate. 7½" × 13½".
Collection, McMaster University.

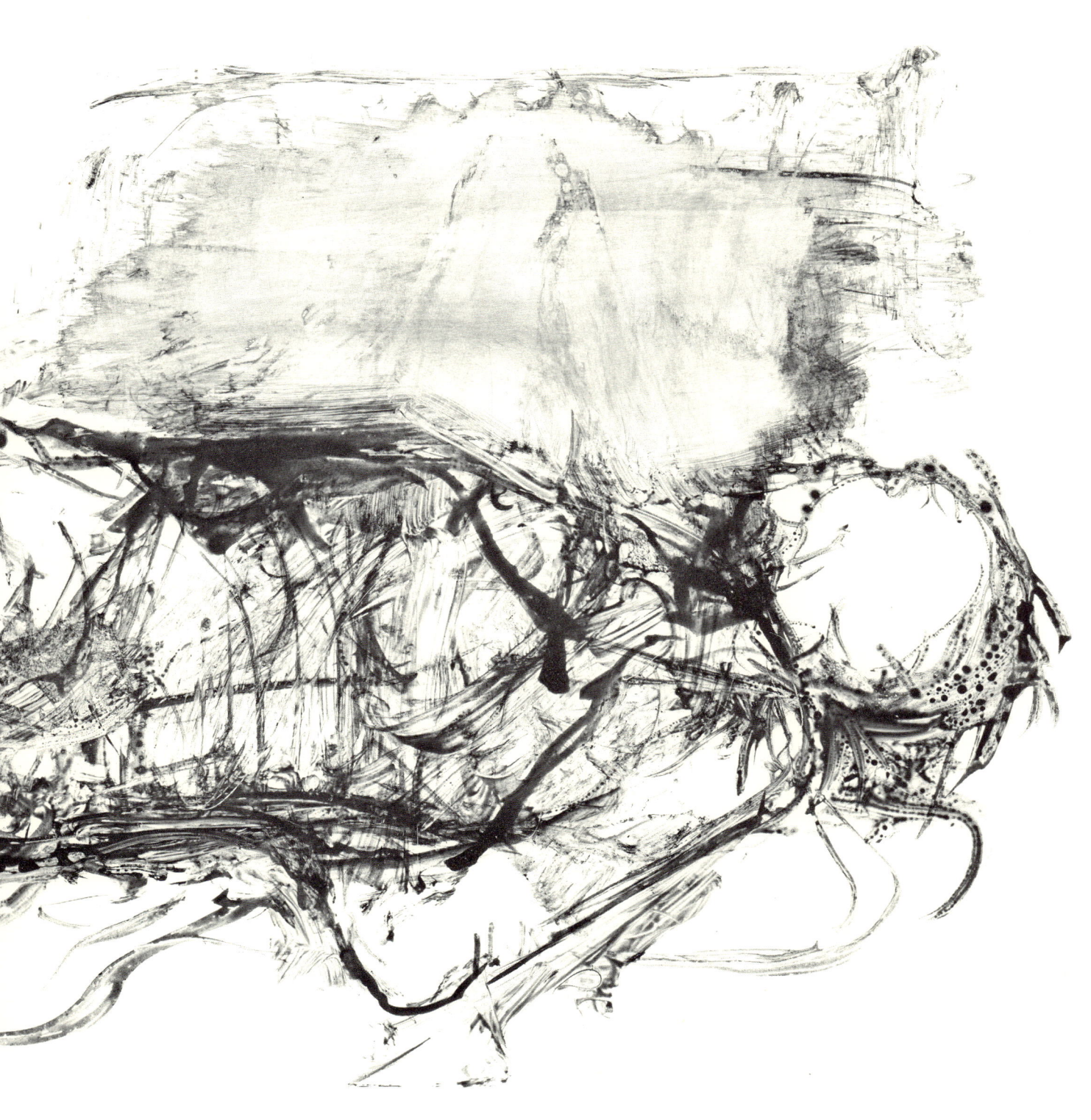

'The Sorcerer' 1966. Pen and Ink Drawing. 15³⁄₈″ × 9″.

'Landscape' 1967. Etching, edition of 100. 26³/₄" × 6³/₄".

'Mole No. 1' 1967. Etching, Artist's Proof, edition of 100. 7″ × 5³⁄₈″.

'Mole No. 2' 1967. Etching, edition of 35. 9¼" × 7".

'Mole No. 3' 1967. Etching and Aquatint, edition of 50. 6⅞" × 4⅞".

'Mole Fantasy' 1967. Etching, Artist's proof of the Second State of Two. 7½" × 6".

'Bird Study' 1968. Etching, edition of 35. $6^{1}/_{2}'' \times 5''$.

'Evil Birds' 1968. Etching, Artist's Proof of First State of Two. 7½" × 6".

'Hummingbird' 1968. Etching, edition of 35. 7$\frac{1}{4}$" × 9".

'Hanging Crow' No. 2' 1968. Etching, edition of 35. Detail. 11$^{5}/_{8}''$ × 14$^{1}/_{2}''$.

'Crow Claws' 1968. Etching, Artist's Proof. 7½" × 7½".

'Between the Tides' 1968. Etchings, Five Artist's Proofs. 2″ × 1½″.

'Mouse Emerged' 1967-68. Etching, edition of 50. 10$^{1}/_{2}''$ × 6$^{1}/_{4}''$.

'Four Heads' 1969. Drypoint, edition of 17. $5^{1}/_{2}''\times 1^{1}/_{2}''$. Collection, McMaster University.

'Head of a Man' 1969. Drypoint, edition of 10. 2½" × 1½".

'Flute Player' 1968. Serigraph, edition of 100. 20″ × 26″. Detail.

'Reed Figure' 1968. Etching with Sugar Lift Aquatint, edition of 35. $14^{3/4}'' \times 9''$.

'Giant's Causeway' 1968. Pen and Ink Drawing. 8″ × 10″.

'Giant's Causeway' 1968. Pen and Ink Drawing. 8″ × 10″.

'Giant's Causeway' 1968. Pen and Ink Drawing. 8" × 10".

'Agaric Form No. 2' 1967. Pen and Ink Drawing. 11″ × 13″.

'Mushroom Study' 1972. Drawing, Pen and Ink, Wash and Brush. 13$^{3}/_{8}''$ × 24''.

'Toros' 1968. Drawing with Ink Wash. 24″ × 18″. Collection of the author. Detail.

'Camel with Foamy Mouth' 1981. Pen and Ink Drawing. 10″ × 7″.

'Monkey' 1977. Watercolour. $8^{1}/_{2}'' \times 11''$.

'The Wise One' 1981. Pencil Drawing. 7" × 10".

'Japanese Monkeys' 1973. Pen and Ink Drawing. 5" × 7".
Collection of Mr. and Mrs. Joseph Lees.

'Hermit Crab' 1969. Water Colour. 17″ × 14″.

SOLO EXHIBITIONS

1962 Westdale Gallery, Hamilton
1963 Westdale Gallery, Hamilton
 Pollock Gallery, Toronto
1964 Pollock Gallery, Toronto
 Westdale Gallery, Hamilton
1966 Pollock Gallery, Toronto
1968 Pollock Gallery, Toronto
1969 University of Guelph
1971 Pollock Gallery, Toronto
1972 Art Gallery of Hamilton
 Pollock Gallery, Toronto
1973 Pollock Gallery, Toronto
1974 University of Guelph
 Pollock Gallery, Toronto
1977 David Mirvish Gallery, Toronto
1978 Diane Brown Gallery,
 Washington, D.C.
1979 Downstairs Gallery
 Klonaridis Inc., Toronto
1980 Diane Brown Gallery,
 Washington, D.C.
 Watson/Willour & Co., Houston
 Contact — Art Gallery of Ontario
 Extension Services
 Klonaridis Inc., Toronto

GROUP EXHIBITIONS

1961 Alan Gallery, Hamilton
 McMaster University, Hamilton
1962 Art Gallery of Hamilton
1963 'Canadian Society of Graphic Art',
 30th Annual Exhibition, Toronto
 Art Gallery of Hamilton
1966 'Canadian Watercolours, Drawings &
 Prints', National Gallery of Canada,
 Ottawa
1967 'Ontario Centennial Art Exhibition',
 Art Gallery of Ontario, Toronto
 Art Gallery of Hamilton
 'Canadian Society of Graphic Art',
 34th Annual Exhibition,
 National Gallery of Canada, Ottawa
1968 'Third International Miniature Print
 Exhibition', IBM Gallery, New York
 Montreal Museum of Fine Arts
1969 'Young Artists Exhibition',
 Union Carbide Building, New York
1970 Scarborough College,
 University of Toronto
 Art Gallery of Hamilton
1971 'Five Lyrical Colour Painters', Art
 Gallery of Ontario Art Rental
 Gallery West, Buffalo
 'Festival of Canada',
 Binghamton, New York
1972 Art Gallery of Hamilton
 '36th Biennale', Venice, Italy
 'Toronto Painting 1953—1965',
 National Gallery of Canada, Ottawa
 'Toronto Today',
 Fleet Gallery, Winnipeg
 'Third International Exhibition of
 Drawings', Museum of Modern Art,
 Rijeika, Yugoslavia
 '12 × 12,' Owens Art Gallery, Mount
 Allison University, Sackville, New
 Brunswick
 'Diversity — Canada East', Edmonton
 Art Gallery and the Norman Macken-
 zie Art Gallery
1973 Pollock Gallery, Toronto
1975 'Made in Canada',
 University of Guelph, Ontario
1976 David Mirvish Gallery, Toronto
 'Ontario Now', Kitchener-Waterloo
 Art Gallery of Hamilton
 'Drawings & Sculpture',
 Art Gallery of Ontario
 'Abstractions', Canadian Pavilion,
 Olympics, Montreal
1977 'Four Toronto Painters', Diane Brown
 Gallery, Washington, D.C..
 David Mirvish Gallery, Toronto
 'Anticipation',
 First Canadian Place, Toronto
 'Bologna Art Fair', Bologna, Italy
 '14 Canadians: A Critic's Choice',
 Hirshhorn Museum & Sculpture Gar-
 den, Washington, D.C.

1977 'New Abstract Art',
　　　Edmonton Art Gallery,
　　　'18 Contemporary Masters',
　　　United States Embassy, Ottawa
　　　'Fauve Heritage',
　　　Edmonton Art Gallery,
　　　'Works on Paper', Galerie Wentzel,
　　　Hamburg, West Germany
　　　'Six From Toronto',
　　　Watson-de Nagy & Co., Houston
　　　'Queen's Silver Jubilee Exhibition',
　　　National Gallery of Canada, Ottawa

1978 'Certain Traditions',
　　　Edmonton Art Gallery
1979 Klonaridis, Inc., Toronto
1980 'Intimate Scale',
　　　Klonaridis, Inc., Toronto
　　　'Aspects of Canadian Art of the Seventies', Glenbow Museum, Calgary
　　　'Show of Klonaridis Inc., Toronto',
　　　Concordia University, Montreal
　　　Cutler-Stavaridis Gallery, Boston

PUBLIC COLLECTONS

The Art Gallery of Ontario, Toronto.
The Canada Council, Ottawa.
Canada Council Art Bank Collection, Ottawa.
The National Gallery of Canada, Ottawa.
National Westminster Bank, Toronto.
The Art Gallery of Hamilton.
McMaster University, Hamilton.
Sir George Williams University, Montreal.
Sir Wilfred Laurier University, Waterloo.
The University of Toronto.
Ontario Institute for Studies in Education, Toronto.
The University of Guelph.
Art Gallery of Windsor.
International Play Group, New York.
Agnes Etherington Gallery, Queen's University, Kingston.
Hirshhorn Museum and Sculpture Garden, Washington, D.C.
Edmonton Art Gallery, Edmonton.
London Art Gallery, Ontario.

BIOGRAPHY

Paul Fournier was born in Simcoe, Ontario, on October 11, 1939. Mainly self-taught, he studied general art techniques under Jean Wishart, Central Secondary School, Hamilton, and printmaking at McMaster University, Hamilton, where he was the guest of Professor George Wallace. In 1969-70, he was Artist in Residence at Waterloo Lutheran University. He has lived in Toronto since 1962.

Fournier has had recent solo exhibitions in Edmonton, Houston and Washington, D.C. Exhibitions at the Hirshhorn Museum and Sculpture Garden ('14 Canadians: A Critic's Choice') and the Diane Brown Gallery, Washington, D.C., in 1977 and 1978, and in New York in 1980 ('The New Generation: A Curator's Choice'), brought Fournier's work to the attention of international collectors. His works hang in the Art Gallery of Ontario, the National Gallery of Canada, Ottawa, the Art Gallery of Hamilton and the Hirshhorn Museum and Sculpture Garden, Washington, D.C., as well as in many university and private collections across Canada and the United States.

Paul Fournier has received first prize at the Aviva Art Show, Toronto, in 1964 and 1978, and second prize in 1966. In 1967, he won the 'C. W. Jeffreys Award', presented by the 'Ontario Society of Graphic Artists'. His first one-man exhibition was at the Westdale Gallery, Hamilton, in 1962. In Toronto, Fournier was formerly associated with the Pollock Gallery and frequently exhibited at the David Mirvish Gallery.

He is presently represented by Klonaridis Inc.